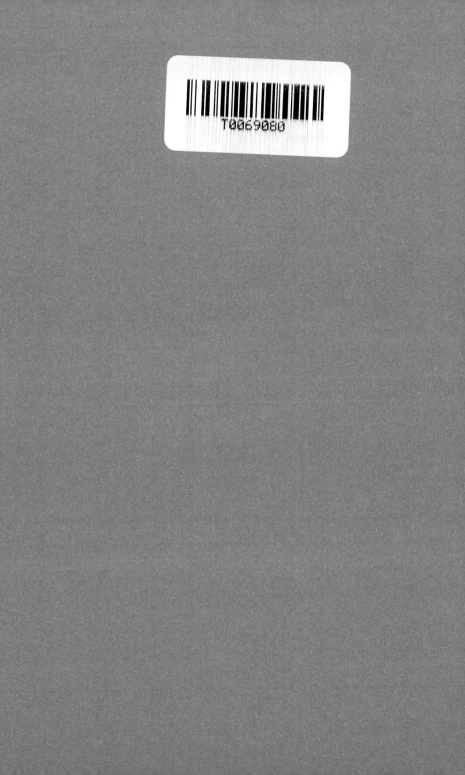

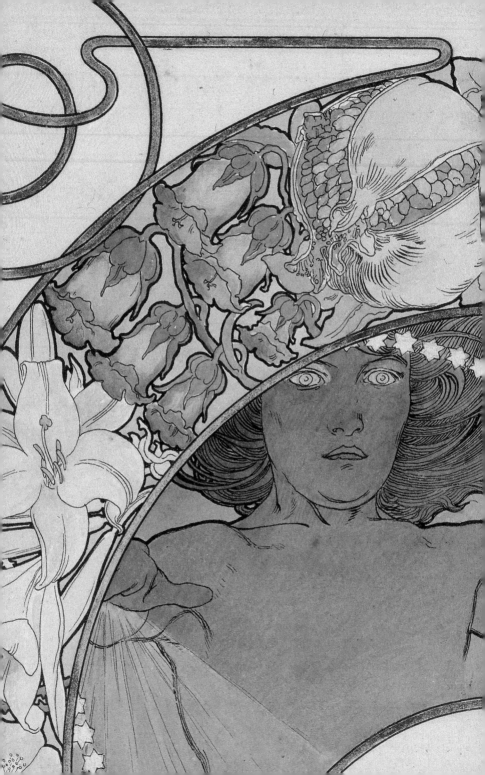

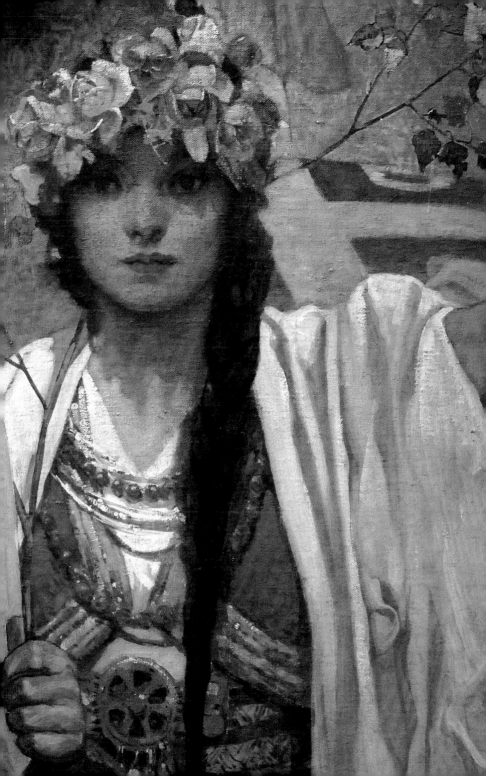

ALFONS
MUCHA

Wilfried Rogasch

HIRMER

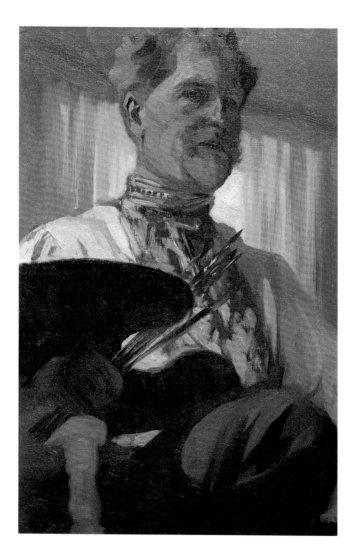

ALFONS MUCHA
Self-Portrait with Palette, ca. 1907
Oil on canvas, 44 × 30 cm

CONTENTS

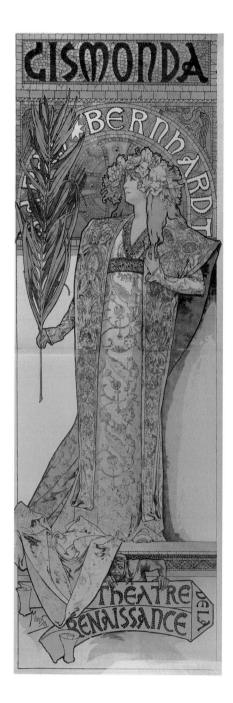

ALFONS MUCHA "THE WORLD'S GREATEST DECORATIVE ARTIST"[1]

by Wilfried Rogasch

AN ARTISTIC BREAKTHROUGH

Paris, 26 December 1894. The thirty-four-year-old Czech artist Alfons Mucha, who had lived in the French capital since 1887, was busy correcting proofs with Maurice de Brunhoff, the director of the Lemercier printing shop. Suddenly they were interrupted by a phone call that would abruptly change Mucha's life. Overnight an illustrator of journals and books known only to insiders was to become a celebrated superstar or, as the *New York Sunday News* would call him in 1904, the "world's greatest decorative artist." On the telephone was the director of the Théâtre de la Renaissance, ordering at short notice a theatre poster for the play *Gismonda* (1) starring the world-famous actress Sarah Bernhardt. The poster needed to be put up by 1 January 1895. Since all the other artists who worked with Lemercier were either away or otherwise occupied over the Christmas holiday, Mucha was given the commission. Although he was well regarded as a craftsmanly

1 *Gismonda, Sarah Bernhardt, Théâtre de la Renaissance*, 1894, colour lithograph, 218 × 75.5 cm
Sprengel Museum, Hannover

and conscientious illustrator, he had not yet designed any theatre posters in Paris. However, he had already produced sketches of Bernhardt as Cleopatra in 1890, and for the Christmas insert of the Paris daily *Le Gaulois* in 1894 he had provided illustrations of the final scenes of *Gismonda*.

Mucha designed a narrow poster more than two metres tall that pictures a nearly life-size Sarah Bernhardt. She is wearing precious brocaded robes and an ornament made of orchids in her flowing, red-blonde hair. A palm branch in her right hand obscures her first name, which is superfluous – everyone knows "La Bernhardt." The semicircle behind the actress, reminiscent of a halo, imitates gold mosaics. The palette is not blatantly garish, but rather composed of soft pastel tones. The outlines are strong, the lines sinuous, and floral elements caress the diva's face – elements that would become typical of Mucha's style in the coming years. Sarah Bernhardt was enchanted, and the public was as well; copies of the poster were repeatedly stolen at night from advertising pillars and walls. In his biography of his father, Mucha's son Jiří quotes a comment by the writer Jérôme Doucet from the Paris journal *Revue Illustrée*: "From one day to the next this poster has taught Paris to know the name Mucha."[2]

Mucha was given a six-year, unprecedentedly lucrative, exclusive contract for the design of all of Bernhardt's posters and stage sets as well as her costumes and jewellery. Critics celebrated Mucha as a prime representative of "Art Nouveau," as the new fin-de-siècle style was known. People spoke of "Le style Mucha," and in German-speaking regions of "Jugendstil", as the epitome of refined elegance and seductive beauty.

CHILDHOOD AND YOUTH

Alfons Maria Mucha was born on 24 July 1860 in Ivančice, a small town in southern Moravia, a region belonging to the Austrian half of the Habsburg dual monarchy Austria-Hungary. At that time the population of Moravia was roughly 70 percent Czech and 30 percent German. Many Czechs, like the Muchas, were determined patriots who felt that the government in Vienna was suppressing Czech language and culture, and who aspired to political self-determination.

Mucha's father, Ondřej Mucha, worked as a court usher; before her marriage his mother Amálie had been a nanny in Vienna. It is commonly

believed that famous artists reveal their talent in earliest childhood, and this was certainly true of Mucha. Family legend has it that Alfons was drawing before he could walk, and that his mother tied a coloured pencil around his neck.

At the age of eleven Alfons left elementary school and was enrolled in the Slavic Gymnasium in Brno, the Moravian capital. With the exception of drawing, he was a mediocre pupil. In 1877 he was expelled from the school without a certificate. On his return to Ivančice his father informed the 17-year-old that he had secured him a position as a court reporter. Mucha, who was anything but a functionary at heart, loathed the work. In his free time he created theatre ornaments, stage sets, posters and programmes for the local amateur theatre and for Czech associations. At the same time, he underwent systematic artistic training under his former drawing teacher from the Brno gymnasium, the well-respected painter Josef Zelený, who believed in him. With the latter's recommendation Mucha applied to Prague's Academy of Art, but was rejected.

VIENNA AND MUNICH

In the late summer of 1879 Mucha read in a Viennese newspaper that the firm Brioschi, Burghart and Kautsky, theatrical painters to the court, was looking for painters for its workshops. Mucha applied and was accepted. In September he moved to Vienna. The imperial city was then at the zenith of its importance, and was attracting talent from all corners of the monarchy. Locally, Hans Makart was the undisputed prince of painters. He had a fondness for large canvases – as would Mucha, who for a long time stood under his spell – produced pompous history paintings and flattering portraits of Viennese society, and celebrated legendary feasts in his atelier. Mucha's employers were considered the leading producers of theatre sets. The three partners employed dozens of painters and craftsmen, and supplied opulent sets and decorations not only to Vienna's theatres but also to others in the Danube monarchy and the German Empire. On 8 December 1881 there was a catastrophic fire in one of these houses that would have serious consequences: the Ringtheater, one of Vienna's largest, went up in flames. It was officially estimated that at least 384 people lost their lives. Overnight Brioschi, Burghart and Kautsky lost one of their

most important clients, and were forced to release some of their workers. As the youngest, Alfons Mucha was among them.

Living in Vienna was too expensive without employment, so after his dismissal Mucha moved to the small South Moravian town of Mikulov, where he managed to secure a modest income by painting portraits of local dignitaries. In due course he became acquainted with Count Eduard von Khuen-Belasi, who had just built the castle Emmahof, near Mikulov, as a new family seat, and who commissioned Mucha to decorate its dining room with wall paintings. In the castle library Mucha was able to study books about Old Masters and modern illustrators, notably the French artists Doré, Daubigny and Meissonier.

Since the young painter had not been subjected to an academic training, he exhibited a fresh and richly varied pictorial vision. Unfortunately, the castle burned in 1945, so we know these early works only from photographs (p. 59). Count Khuen-Belasi was so pleased with Mucha's work that he recommended him to his brother Egon in Tyrol, where the painter produced additional wall paintings in Castle Gandegg, the original family seat near Bolzano.

The painter Wilhelm Kray, a visitor at Gandegg, suggested to his young colleague that he apply to the Academy of Arts in Munich. So at twenty-five Mucha became enrolled in an art school for the first time. He sublet a room at Amalienstrasse 53, only steps away from the Academy. During his entire stay in Munich he was supported financially by Eduard Khuen-Belasi.

Since the late nineteenth century Munich's Academy had been considered the German Empire's leading art school, ahead of those in Berlin, Dresden and Düsseldorf. Associated with it are such major names from art history as Franz von Lenbach, Franz von Stuck, Adolf von Hildebrandt, Peter von Cornelius, Ludwig von Schwanthaler and Carl Theodor von Piloty. Mucha's teachers were Ludwig von Löfftz and Ludwig von Herterich, both undistinguished painters but good pedagogues. His work now found official recognition: it is said that he was awarded a prize for an altarpiece picturing the Slavic apostles Cyril and Methodius (2) that he had painted for an American Czech congregation in Pisek, North Dakota.

2 *The Slavic Apostles Cyril and Methodius*, design for an altarpiece in the Church of Saint John Nepomuk in Pisek, North Dakota, U.S.A., 1886, oil on canvas, 85 × 45.5 cm, private collection, Czech Republic

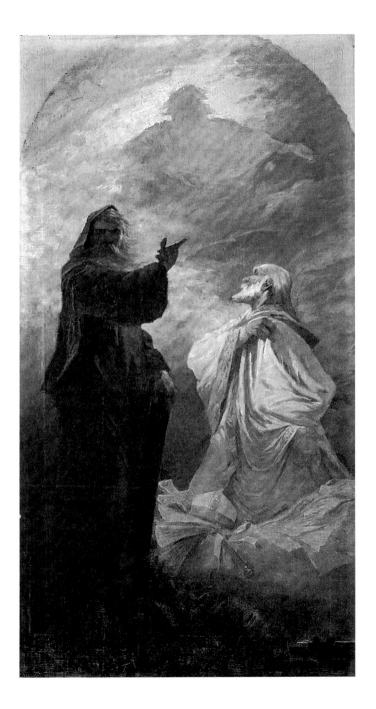

The Khuen-Belasi brothers encouraged Mucha to continue his studies in either Paris or Rome. He chose the French capital, and in the fall of 1877 rented a room near the Rue du Faubourg-Saint-Denis and enrolled in the respected Académie Julian, a private art school operated by the painter Rodolphe Julian. Of all the Paris art schools in competition with the state-run École des Beaux-Arts, it was the best known. Its graduates have included Ernst Barlach, Pierre Bonnard, Lovis Corinth, Marcel Duchamp, Georg Kolbe, Käthe Kollwitz, Fernand Léger, Henri Matisse, Max Slevogt and Édouard Vuillard.

Paris was a vibrant metropolis with a lively art scene, and French painting – largely ignored in Munich and Vienna – was considered Europe's finest. In the middle of the nineteenth century, under Napoleon III, Georges-Eugène Baron Haussmann had begun a redesign of the metropolis that continued into the 1880s. The new boulevards slicing straight through what was still an urban cityscape from the Middle Ages gave Paris the appearance it has to this day. And in 1887 the Eiffel Tower began soaring upward to serve as a symbol of the 1889 World's Fair.

Mucha was known to be sociable and charming. In both Munich and Paris he was an active member or chairman of Czech artists' associations. Yet he did not align himself with any specific movement or school, but rather chose to go his own way. His political ideas were developed during his Paris years, and ultimately boiled down to three doctrines: Czech nationalism, with its hope for independence for the Czechs; a spiritual union of all of Europe's Slavic peoples, or Panslavism; and a humanism embracing all of the world's peoples. To a certain extent it can be said that in 30 years, thanks to his sojourns in Vienna, Munich, Paris and later the United States, Mucha became an international citizen. At times he showed an interest in mysticism, as was fashionable in the late nineteenth century. He was particularly honoured to be initiated into the oldest Freemasonry lodge in Paris. He also came to know and admire representatives of Symbolism and the Nabis; the Impressionists, however, did not influence him at all.

Mucha was convinced that industry was just as important as talent. So he kept to a precisely set daily routine: he worked at the Académie Julian from 8:30 to 12:00 in the morning and 2:00 pm to 5:00 pm in the afternoon

every day except Sunday, then until late at night at home. His teachers at the academy, Jules-Joseph Lefebvre, Gustave Boulanger and Jean Paul Laurens, exercised a profound influence on him, as is especially visible in Mucha's late work the *Slav Epic* (20–26). Lefebvre achieved social recognition for his paintings of charming female nudes and was a sought-after portraitist. Boulanger's equally popular work can be classed as Salon painting and to some extent Orientalism. And Laurens is considered the last great representative of French history painting.

In 1888 Mucha transferred to the noted private Académie Colarossi in the 6th arrondissement. It was run by the Italian sculptor Filippo Colarossi and like the Académie Julian vied with the state-run École des Beaux-Arts. Its pupils came from all over Europe and the United States. A list of its graduates reads like a Who's Who in the arts from roughly 1880 to 1914, including such famous names as the French artists Paul Gauguin and Camille Claudel, the German-American Lyonel Feininger, the Norwegian Olav Gulbransson, the German painters Wilhelm Lehmbruck and George Grosz, and the Italian Amedeo Modigliani.

MUCHA AS ILLUSTRATOR

In early 1889 Mucha received bad news: Count Eduard von Khuen-Belasi's secretary informed him that his patron had decided to withdraw his financial support, which had amounted to 200 francs a month, with immediate effect. Khuen-Belasi later explained that he had felt it was time that the 28-year-old learned to stand on his own two feet.

As it happened, after an initial rough patch Mucha managed to secure relatively profitable commissions as an illustrator for journals and books and to establish a reputation as a reliable business partner. Publishers were highly satisfied with his work, and word of mouth continued to expand the circle of his clients. Visually attractive books were selling well in France and in the rest of Europe at the time. Members of a well-to-do educated bourgeoisie were eager to acquire libraries of their own, and publishers virtually stopped issuing books without illustrations and decorative ornaments. Mucha had a notable success with his 33 illustrations for the book *Scènes et Épisodes de l'Histoire d'Allemagne* by the French historian Charles Seignobo. The Czech patriot had been especially motivated in the

scenes relating to Bohemian history, like the depiction of *Emperor Rudolf II and His Astrologer* and *Wallenstein's Assassination*. His *Death of Friedrich Barbarossa* (3) became especially well known. Mucha placed the corpse of the emperor, who had drowned in the river Saleph, in the midst of gnarled trees next to the riverbank. Near it stands a dominant dark, enigmatic figure in a monk's habit gazing at the dead emperor. The figure's face is obscured by the cowl, evoking associations with Death.

Faithful to his belief in making art not for art's sake but for people, Mucha remained true to book illustrating during his entire sojourn in Paris. He considered his masterpiece in the genre to be his *Le Pater* (*The Lord's Prayer*) (4), which he completed in 1899 and proudly displayed at the Paris World's Fair in 1900. The book included not only Christian symbols, but

3 *The Death of Frederick Barbarossa*, 1898, illustration for Charles Seignobos's *Scènes et Épisodes de l'Histoire d'Allemagne*, published by Armand Colin et Cie., Paris

also those of other religions and cultures as well as of Freemasonry, which fascinated some critics but was condemned by others.

From 1890 to 1896 Mucha lived as a sub-tenant with the widow Charlotte Charon. She ran a crèmerie at Rue de la Grande Chaumière 13, a kind of snack bar where for little money artists from the nearby Académie Colarossi could get a warm meal. The motherly Madame Charon also occasionally accepted pictures from penurious artists in lieu of cash, and these adorned the restaurant's walls. It was in the crèmerie that Mucha became acquainted with Paul Gauguin, who at the time was preparing for his first trip to Tahiti. A friendship developed between the two very different artists. Other close acquaintances were the Swedish writer August Strindberg and the French sculptor Auguste Rodin, with whom Mucha journeyed to Prague in 1902.

Mucha began teaching art at the Académie Colarossi in 1892. After his artistic breakthrough, his class was advertised as the "Cours Mucha." In 1896, now in his mid- thirties and having "arrived," he moved to the elegant Rue du Val-de-Grâce, where he presented himself as a painter-prince in opulent interiors like Makart in Vienna and Lenbach and Stuck in Munich. His atelier was frequented by almost everyone of any importance in Paris's art and theatre worlds. There Mucha also devoted himself intensively to photography: some 1,500 photographs of his survive, from erotic depictions of young female models to single figures and groups that he then integrated into his pictures and portraits of himself as a successful artist.

AT THE HEIGHT OF HIS FAME

Mucha's incomparable career as a poster artist began after he was awarded the above-mentioned *Gismonda* contract in 1894. In the Belle Époque the advertising poster became a highly effective visual element in public spaces. Other successful poster artists worked in Paris along with Mucha, including Jules Chéret, Eugène Grasset and Henri de Toulouse-Lautrec. After the great success of the *Gismonda* poster, which was printed in an edition of 4,000 and was posted on virtually every street corner in Paris, by 1900 Mucha had created another six theatre posters for Sarah Bernhardt that number among his masterworks. In style and composition they formed a set, underscoring the diva's cult status. They advertised *La Dame aux*

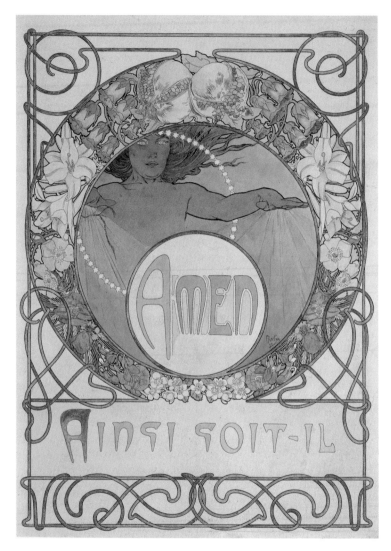

4 *Amen*, final design sketch for the last page of the book *Le Pater* (*The Lord's Prayer*), 1899
Private collection, Switzerland

5 *Sarah Bernhardt*, full-figure study, ca. 1896, indelible pencil on paper, 41.5 × 26 cm

Camélias (6), *Lorenzaccio* (7), *La Samaritaine* (8), *Medea* (9), *Hamlet* (10) and *Tosca*. Like the *Gismonda*, they were all designed in tall format with a 3:1 height to width ratio. The *Dame aux Camélias* is considered an early icon of Art Nouveau poster art. On all of them we find the same sinuous lines of drapery, and on the *Samaritaine* the same long, thick strands of wavy hair – a Mucha trademark that critics disrespectfully referred to as "macaroni."

Sarah Bernhardt was unquestionably the most famous actress of her time. Extensive guest tours took her to almost every country in Europe – except for Germany, which as a patriotic Frenchwoman she refused to visit after the loss of Alsace-Lorraine in 1871. In the United States she appeared in 51 different cities. She gathered around her a "royal" court composed of admirers, lovers and benefactors, to which Mucha was admitted. "The Divine Sarah" was considered highly eccentric: she never contradicted the legends that arose like the one that insisted that she slept in her coffin.

Mucha recalled his first encounter with Sarah Bernhardt at the turn of the year 1894/95: "I was led to Sarah's dressing room, and there for the first time I saw her face to face. But immediately I sensed a clear, pure aura, and that gave me hope. My poster hung on the wall; Sarah was standing in front of it and couldn't take her eyes away from it. When she caught sight of me she rushed toward me, embraced me, and showered me with praise. In short, no disgrace, but a success, a great success. ... And Sarah wouldn't let me go. I worked for her a total of six years before her departure for America in 1901. And even then I still worked for her occasionally."[3]

The public success of his Bernhardt posters brought Mucha fame even beyond France's borders, everywhere the diva deigned to appear. A flood of well-paid commissions came to him from all branches of the rapidly expanding world of consumer goods: he produced advertising posters, paper and metal packaging, calendars (11) and other pieces of giveaway advertising for crackers and chocolate, beer, liquor and champagne, baby food, soaps and ladies' perfume, cigarette papers (12), bicycles (13) and railway lines (14). In almost all of them a beautiful young woman with long hair is promoting the product. France, the rest of Europe, and finally the United States could not get enough of the famous "Mucha women." They are seductively soft or alluring in their animated poses, and are rendered in a muted, sensuous palette frequently dominated by peach, ochre, olive and other pastel shades. To this day they are considered to be icons of Art Nouveau.

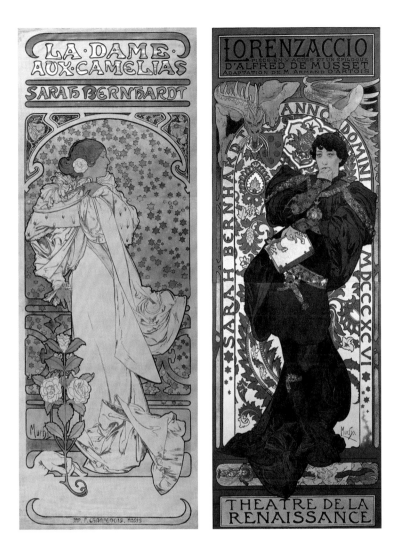

6 *La Dame aux Camélias, Sarah Bernhardt*
Colour lithograph, 1896, 207 × 77 cm

7 *Lorenzaccio d'Alfred de Musset,*
Théâtre de la Renaissance, 1896
Colour lithograph, 203.7 × 76 cm

8 *La Samaritaine, Sarah Bernhardt,*
Théâtre de la Renaissance, 1897
Colour lithograph, 173 × 58.3 cm

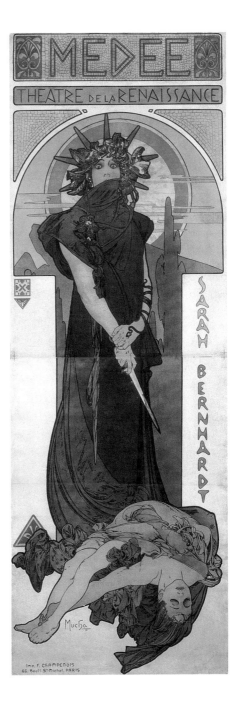

9 *Médée, Sarah Bernhardt,*
Théâtre de la Renaissance,
1898, colour lithograph
201.5 × 75 cm

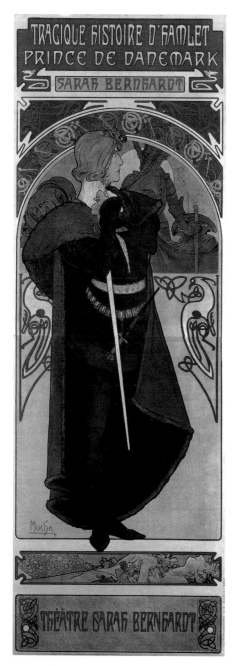

10 *Tragique Histoire d'Hamlet,*
Prince de Danemark, Sarah Bernhardt,
Théâtre de la Renaissance
Colour lithograph, 207.5 × 76.5 cm

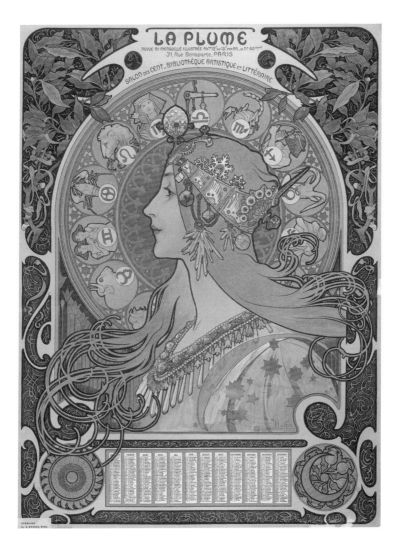

11 *Zodiac Signs*, 1896, illustration for
the 1897 calendar of the journal *La Plume*
Colour lithograph, 65.7 × 48.2 cm

Together with his printer, F. Champenois, Mucha also developed so-called *Panneaux décoratifs*, graphics with no advertising message. They were meant to celebrate the beauty of young women and serve as tasteful wall décor. By this time the technique of colour lithography had been refined, permitting high-quality prints to be produced at modest prices. Mucha felt gratified that his art was issued in quantity and that his posters could be purchased even by people who were not so well-off. Beginning in 1896 nearly fifty of these decorative, allegorical graphics were produced in rapid succession, among them the *Four Seasons*, *Four Flowers*, *Four Gems*, *Four Arts* (15–18), *Four Times of Day*, and *Four Stars*. It is unsurprising that in this phase of his greatest successes he continually complained of being overworked. In 1904, when he set out on his first trip to the United States, he wrote in retrospect about his time in Paris: "I feared namely I would have to stay in the treadmill in which I functioned in Paris forever, and would never get to do what I really wanted. I would have been permanently at the mercy of publishers and their whims."[4]

Mucha followed his own path in terms of iconology: the advertised product or the meaning of an allegory is frequently not recognisable at first glance. On an advertising poster for the Paris–Monte Carlo railway (14), for example, there is no depiction of a train. But with a little imagination, it is possible to think of the large, wheel-like circles of plant and bird motifs behind the kneeling woman as the giant wheels of a locomotive.

For the depiction of music in the *Four Arts* series Mucha did without such traditional symbols as instruments, instead picturing a sensuous young woman listening intently. Songbirds in the background help to identify her with music. The *Dance* poster from the same series features dynamic movement, with the formidable sweep of the figure's garment and long hair.

By the spring of 1899, Mucha's fame had also reached Vienna, and he received two commissions from there for the coming World's Fair. One was for the poster *Austria at the World's Fair, Paris 1900*, which pictures two allegorical female figures: the depiction of the City of Paris is lifting the veil of the personification of Austria, in illustration of the motto: "Paris introduces Austria to the world."

The other was the much larger commission for the design of the Bosnia-Herzegovina Pavilion. That Balkan region, previously Turkish, had been under Austrian rule since 1878. The government of Austria-Hungary

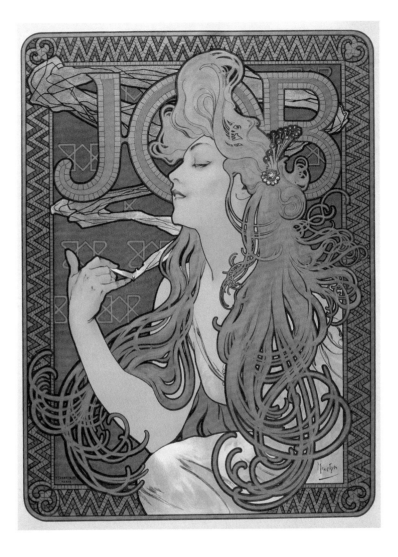

12 Advertisement for the cigarette paper *Job*, 1896
Colour lithograph, 66.7 × 46.4 cm

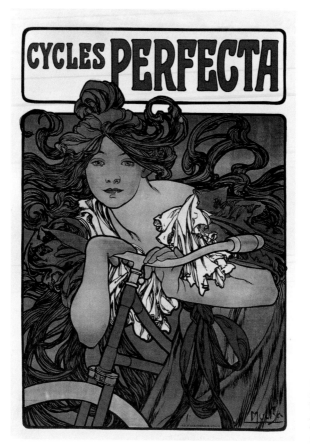

13 Advertisement for the bicycle brand *Cycles Perfecta*, 1902 Colour lithograph 150 × 105 cm

wished to show the world how within twenty years it had fostered Western civilisation there, thereby preparing by way of propaganda for Bosnia's ultimate annexation. On a research trip to Bosnia, Mucha gathered impressions and captured them in numerous drawings and photographs. His idealistic vision of Bosnia's political potential, presented in the pavilion's wall paintings, is one of the peaceful co-existence of three cultures and religions, Catholicism, Orthodox Christianity and Islam.

Mucha later recalled that it was in Bosnia, home to South Slav Serbs and Croats, that he first had the idea of devoting a monumental picture cycle

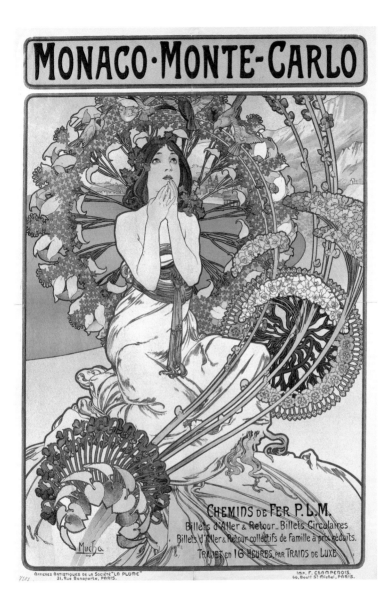

14 *Monaco-Monte-Carlo*, poster for the railway line P.L.M. (Paris–Lyon–Marseille), 1897
Colour lithograph, 108 × 74.5 cm, Museum Folkwang, Essen

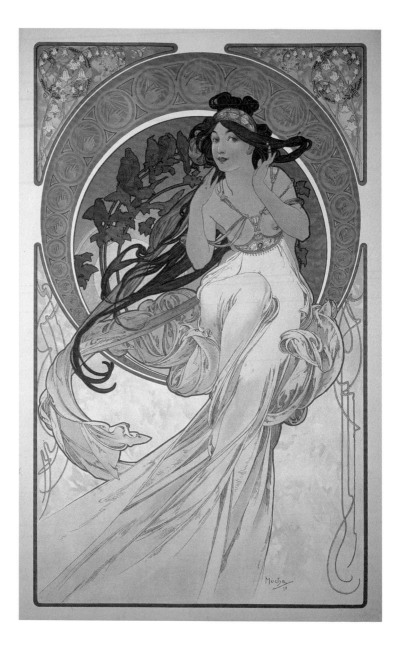

15 *The Arts: Music*, 1898, colour lithograph, 60 × 38 cm, Mucha Museum, Prague

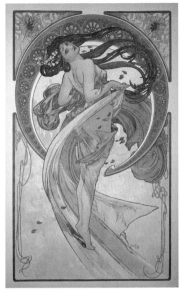

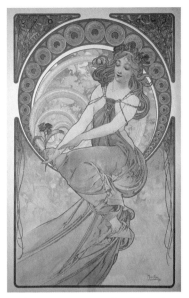

16　*The Arts: Dance*, 1898, colour lithograph
60 × 38 cm, Mucha Museum, Prague

17　*The Arts: Painting*, 1898, colour lithograph
60 × 38 cm, Mucha Museum, Prague

to Slavic history as a whole. But first there were other lucrative jobs that needed to be finished in Paris, one for the jeweller Georges Fouquet in the Rue Royale, for example. With his design of the shop's façade and the entire interior décor he created a Gesamtkunstwerk in the "Mucha style": floral elements on the wall coverings, the ceiling, the floor and the show-cases set the stage for the baubles sold there, some of them designed by Mucha himself. A pair of decorative peacocks symbolised beauty and luxury. The interior was later enshrined in Paris's Musée Carnavalet, where it can be admired today (pp. 72/73).

While decorating the Fouquet shop, Mucha produced a pattern book in folio format, the *Documents décoratifs*. On 72 plates he pictured artistically designed everyday objects of all kinds based on forms from nature, examples that could serve craftsmen as inspirations for their own designs. Included were china, flatware, jewellery, furniture, lamps, wallpapers, carpets and posters. His drawings once again display Mucha's virtually limitless imagination as well as his ability to create harmoniously arranged

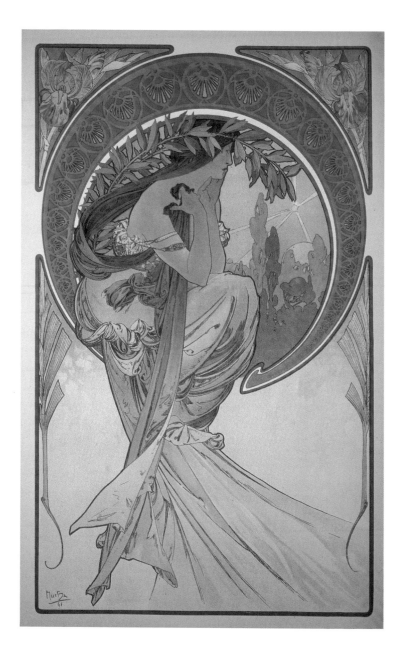

18 *The Arts: Poetry*, 1898, colour lithograph, 60 × 38 cm, Mucha Museum, Prague

book pages with his designs. It pleased him to see that his handbook was used in any number of applied art schools not only in France, but in all of Europe, thus fulfilling his wish to make his art of use to mankind (p. 74).

MUCHA IN THE UNITED STATES

In 1904, at the zenith of his fame, Mucha made his first trip to the United States. Five more would follow by 1913. He sought escape from the constant demands of his publishers and clients in Paris, and he also hoped to find well-heeled patrons in the New World for his planned monumental masterpiece, the *Slav Epic*. An acquaintance, Baroness Leonora de Rothschild, had also suggested that he could become enormously wealthy by painting portraits of the American upper class. But unlike such high-society painters as John Singer Sargent and Philip de László, he was not to succeed as a portraitist to the beautiful, wealthy and powerful. His strength lay in the portrayal of idealised lovely young women. It was difficult for him to produce likenesses of real women who sat for him. Mucha's sittings were stressful for both painter and model, especially since he was not satisfied with his pictures and frequently overpainted them. But in his most important endeavour, finding a patron for his great project, he was successful.

He met the millionaire history buff Charles Richard Crane, the man who would ultimately finance the *Slav Epos* – although it was not until Christmas 1919 that Crane decided to underwrite the entire project. When he telegraphed his commitment from Cairo, Mucha excitedly wrote his wife: "Crane has completely accepted my proposal. I have already received the first cheque, 7,500 dollars. … I have bought myself tempera colours and will make samples with them. … My work has to be like separate outcries, without any affectedness, in a bravura technique, sincerely felt, sincerely communicated."[5] Crane was not only wealthy; he was also well connected. He numbered among his friends the later U.S. president Woodrow Wilson, who supported the establishment of Czechoslovakia in 1918. Crane had become interested in Czech and Slavic history after getting to know Tomáš Garrigue Masaryk, later Czechoslovakia's first president.

During the period in which Mucha visited the United States he married Maria Chytilová (1882–1959), whom he fondly referred to as "Maruška." It was love at first sight. She had briefly been a pupil of his in Paris, and at the

time of their wedding in Prague in 1906 she was 23 years old, Mucha 46. It was a happy marriage, and produced two children: Jaroslava (1909–1986) and Jiří (1915–1991). Jaroslava would assist her father in his work on the *Slav Epic*, and serve as his model for numerous figures; Jiří became a writer and Mucha's most important biographer.

PRAGUE

In 1909 Mucha was commissioned to decorate Prague's Municipal House with paintings. The imposing structure in the Art Nouveau style had been under construction since 1906, replacing the medieval palace of the Bohemian kings. It was meant to represent the humiliation and revival of the Czech nation in the conflict between Czechs and Germans. Mucha saw the summons as a chance to serve his country, and intended to charge his client only the cost of his materials. In this Mucha proved to be a typical child of his time; like the rest of the bourgeois Czech élite he saw the retelling of Czech history in art as an important stimulus toward the recovery of political independence. But when it became known that local artists were to be passed over in the building's decoration, the press unleashed a storm of protest. Mucha was branded an outsider, a man who had lived as a cosmopolitan in Paris and the United States for decades. Opposition to Mucha in the Prague art scene was so vocal that it was decided that he should decorate only the central Primators' Hall (Mayors' Hall), while the numerous other halls, assembly rooms and the restaurant would be painted by local Czech artists. Mucha's painting in the hall's cupola pictures the *Unity of the Slavs*, with figures holding hands to form a circle. The pendentives feature eight figures from Czech history who embody the bourgeois virtues that served as the nation's strength. The wall paintings glorify Slavdom in multiple allegories. They herald a new phase in Mucha's career: whereas female figures had dominated his previous work, these Prague pictures are largely populated by men.

Mucha produced his *Slav Epic* between 1910 and 1928, during the period that saw the First World War, the collapse of the Habsburg monarchy, and the long-desired establishment of an independent Czech nation. Mucha himself considered the cycle to be his most important work, and in view of its scope and the time he spent on it, he was certainly correct. It is comprised of 20 huge canvases; the seven largest are 6.10 metres tall and 8.10 metres wide, the others only slightly smaller. In all of art history there is probably no other work on which a painter laboured for 18 years.

Realistic history painting arose as a picture genre in the Renaissance, and attained its greatest flowering in the age of nationalism in the nineteenth century – often taking the form of giant-format wall and ceiling paintings or very large canvases. Jacques-Louis David, Paul Delaroche and Jean-Léon Gérôme were noted practitioners of the genre in France, and Adolph von Menzel and Anton von Werner in Germany. The most important Polish painter of the nineteenth century, Jan Matejko, never tired of holding up to his fellow countrymen the mirror of a glorious past in which the Poles surpassed the Germans and Russians both militarily and politically.

In 1911 Mucha rented Zbiroh Castle in western Bohemia. There he found the isolation and necessary space in which to work on his monumental cycle. He decided to devote ten paintings to Czech history and ten to the history of other Slavic peoples and the Slavic past in general. Mucha was convinced that within the Slavic family of peoples the Czechs had attained the highest level of culture, and could serve as a model for the others. The work was to illustrate more than a thousand years of history, from the emergence of the Slavs in the distant past up to 1861, the year serfdom was abolished in Russia – a subject Mucha's patron Charles Crane wished to see included.

Mucha spent a great deal of time reading the literature to be certain that his works were historically accurate. He carefully studied the monumental *History of Bohemia* by the father of Czech history writing, František Palacký. Also, following up on his first tour of the Balkans in 1899, he made extended tours through the European regions inhabited by Slavs: Dalmatia with his wife in 1912, Poland and Russia in 1913, the Balkans again as far as Bulgaria in 1924 and on to the monastic republic Athos in Greece. Along the way he produced countless virtuosic sketches and

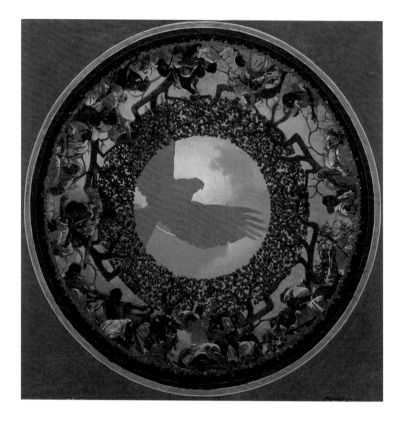

19 *Unity of the Slavs*, 1910/11, design for the ceiling painting in the main hall of Prague's
Obecní dům (Municipal House), oil on canvas, 120 × 120 cm, Galerie hlavního města Prahy, Prague

photographs to be evaluated after his return. The *Slav Epic* is not only committed to realism, it is also richly imbued with symbolism. Mucha made use of countless symbols from Christian and pagan mythology, including some he devised himself. Many pictures include floral wreaths, for example, and other circular motifs as symbols of Slavic unity. Comparing this colossal undertaking with his poster art in the "Mucha style," we might come to the conclusion that they are the work of two different artists.

Mucha started his cycle with the painting *The Slavs in Their Original Home* (20). In a night scene a frightened couple is hiding from the hostile horde that has set fire to their village in the background. The couple's white clothing symbolises innocence. Mucha gave the picture the subtitle *Between the Turanian Whip and the Gothic Sword*. The message is simple: the peaceful Slavs had been continually attacked and subjugated by their aggressive neighbours. The Turanians were meant to represent the Turks, the Goths, the Teutons or Germans. A pagan Slavic priest is begging the gods for mercy for his people. A girl beneath his left arm symbolises peace, a youth under his right stands for "righteous war," suggesting that though actually peace-loving, the Slavic peoples have a right to fight for their freedom.

Following the paintings *The Celebration of Svantovit* (21, 22) and *The Introduction of the Slavonic Liturgy* come three multifigured pictures celebrating important Slavic rulers from the Middle Ages: Tsar Simeon of Bulgaria, King Ottokar II of Bohemia and Tsar Štěpán Uroš IV Dušan of Serbia (23). Croatia is represented by the military leader against the Turks, Nikolaus Zrinski. The painting dedicated to Poland pictures the devastated battlefield after the Battle of Grunewald in 1410, in which the Polish king Władysław II Jagiełło roundly defeated the Knights of the Teutonic Order – perhaps Poland's most important national myth.

The next five works have to do with Jan Hus and the Hussites (24). Hus was a Czech theologian and reformer who successfully linked his notions of ecclesiastical reform to a Czech national consciousness. Burned as a heretic at the Council of Constance in 1415, he became the most important Czech martyr and a national hero.

The subject of the penultimate painting is the abolition of serfdom in Russia (25). The picture shows Red Square in Moscow with St. Basil's Cathedral and the Kremlin in the background. On this stage Mucha placed crowds of liberated but destitute Russian serfs, who scarcely know what to do with their newly won freedom.

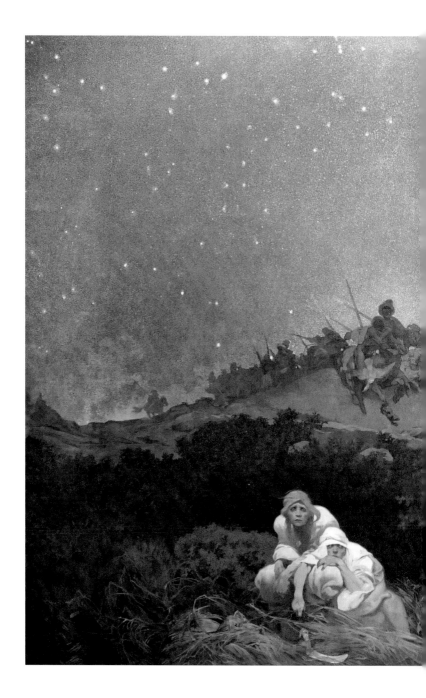

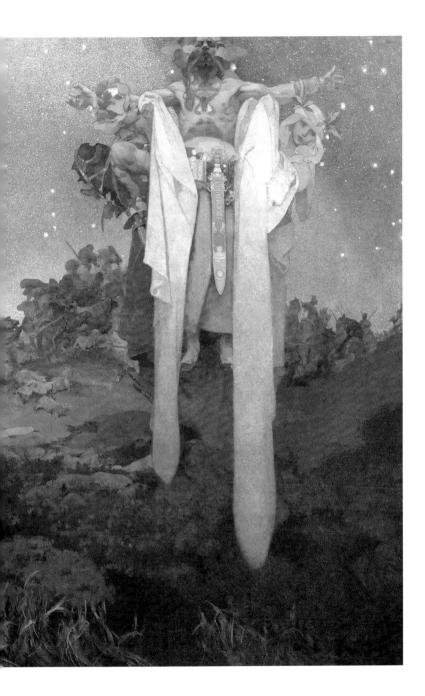

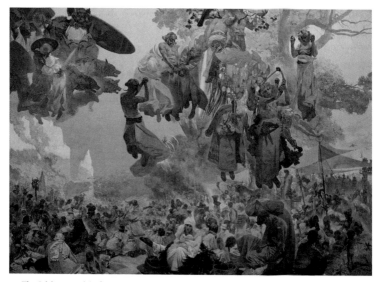

21 *The Celebration of the Svantovit on Rügen Island*, 1912
Egg tempera on canvas, 610 × 810 cm, Galerie hlavního města Prahy, Prague

The final work bears the title *The Apotheosis of the Slavs. Slavs for Humanity* (26). In it a large male figure with outspread arms symbolises both the sufferings and aspirations of the Slavic peoples. Czechoslovakia's political allies, above all the United States and France, are symbolised by their flags. A rainbow appears in background as a sign of hope. Christ himself appears behind the male figure giving his blessing.

In 1928, on the tenth anniversary of Czechoslovakia's founding, Mucha and Crane presented the colossal epic, displayed in the exhibition hall, to the City of Prague. The response was muted. Well-meaning critics recognised

previous double page:
20 *The Slavs in Their Original Home*, 1911
Egg tempera on canvas, 610 × 810 cm, Galerie hlavního města Prahy, Prague

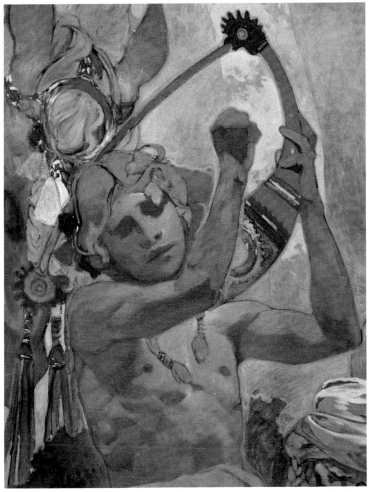

22 Detail from *The Celebration of the Svantovit on Rügen Island*, 1912
Galerie hlavního města Prahy, Prague

following double page:
23 *The Coronation of the Serbian King Stephan Dušan as East Roman Emperor*, 1923
Egg tempera on canvas, 405 × 480 cm, Galerie hlavního města Prahy, Prague

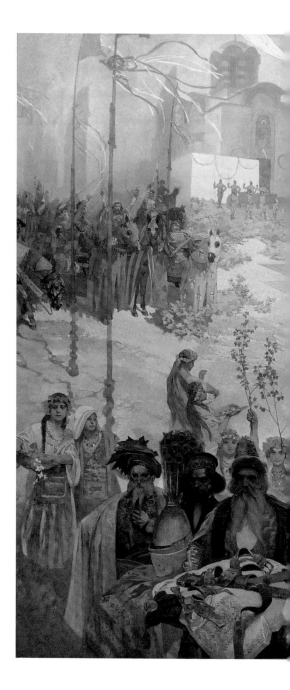

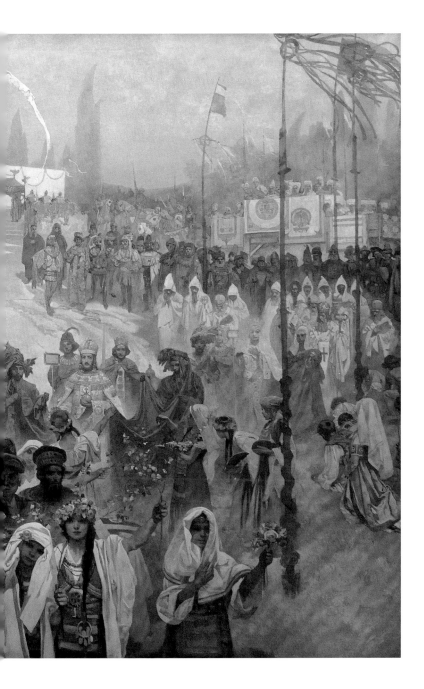

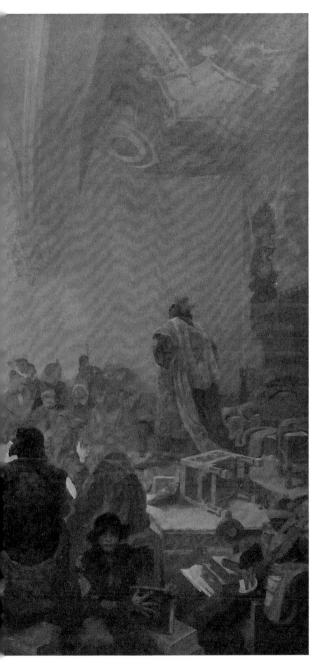

24 *The Hussite King Georg von Podiebrad and the Papal Legate Fantin de Valle,* 1923
Egg tempera and oil on canvas
405 × 480 cm
Galerie hlavního města Prahy, Prague

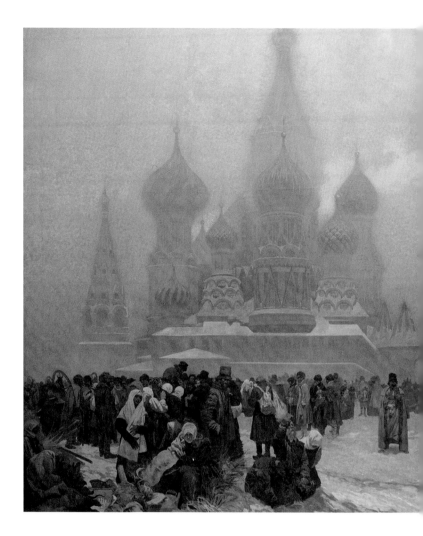

25 *The Abolition of Serfdom in Russia*, 1914
Egg tempera on canvas, 610 × 810 cm, Galerie hlavního města Prahy, Prague

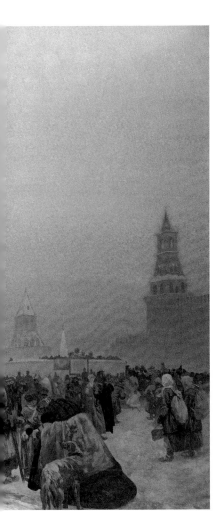

Mucha's ardent patriotism and incredible effort, and praised individual compositions and the sheer abundance of detail. But there were also many negative reviews; the Modernists considered history painting, Symbolism and Panslavism all to be outmoded. To them Mucha's work was an anachronism. Any alliance between bourgeois Czechoslovakia and the "Slavic" Soviet Union, for example, seemed unthinkable, and unity among Europe's Slavic peoples a mere pipe dream. In addition, there were complaints that

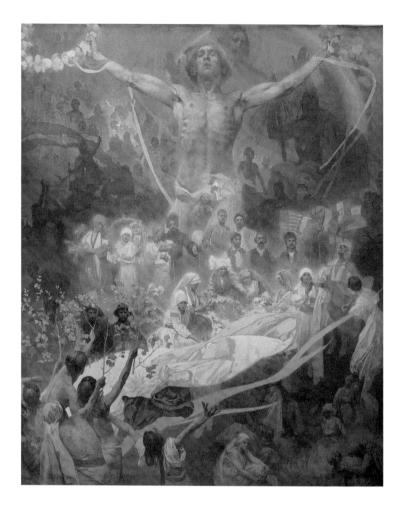

26 *The Apotheosis of the Slavs*, 1926
Egg tempera on canvas, 480 × 405 cm, Galerie hlavního města Prahy, Prague

many of the scenes Mucha had chosen were recognised by a few historians, to be sure, but not by the Czech populace. There were also extremely positive appraisals: William Henry Goodyear, a leading American art critic and curator of the Brooklyn Museum of Art, was among the work's fervent admirers: "I consider … the *Slav Epic* to be the greatest work of its kind since the beginning of the sixteenth century. … To the extent that one can compare it to modern pictures of the same type; the only ones that come close to it are the Puvis de Chavannes frescoes in the Pantheon and the Kaulbach frescoes on the walls of the Berlin Museum's main stairwell. Yet your work towers above all these in composition, colouring, execution of details, and overall concept of the subject matter. That you have successfully mastered these problems more successfully than any other contemporary makes you in my opinion a leading painter, superior to all the nineteenth-century ones as well."[6]

The cycle has had a chequered history. After being displayed in Prague and Brno it was placed in storage, and in 1939 hidden away to protect it from the clutches of the German occupation. After the Second World War it was again on view in various places – between 1963 and 2012, for example, at the castle in Moravský Krumlov, less than 12 kilometres from Ivančice, Mucha's birthplace, then once again in Prague's exhibition hall for a few years. Finally in 2018 portions of it were exhibited in Brno along with other Mucha works.

THE LAST YEARS

In the 1930s Mucha was rarely spoken of. As one of his last major commissions he designed a multifigured, richly coloured stained-glass window for the new Archiepiscopal Chapel in Prague's St. Vitus Cathedral, which had been under construction for 600 years and was finally completed in 1929. The window, executed by the glass artist Jan Veselý in 1931, features episodes from the lives of the Slavic apostles Cyril and Methodius as well as the Czech saints Ludmila and Wenceslas. Beneath Christ giving his blessing there is the allegorical figure of Slavia, a reference to the Prague insurance company of the same name that financed the work. Mucha's cartoons for the cathedral window are considered to be his best works after the *Slav Epic*.

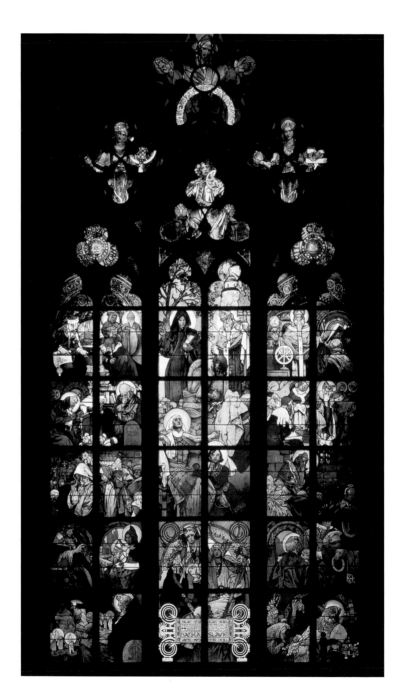

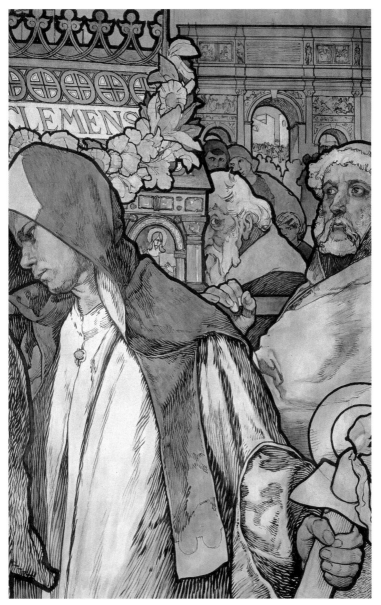

28 Cartoon for a scene in one of the stained-glass windows in St. Vitus Cathedral, 1931, pastel on paper, 125 × 160 cm

27 Stained-glass window in Prague's St. Vitus Cathedral, ca. 1930/35, 125 × 160 cm

A few years later, in 1936, he was remembered in Paris for his long career there in a retrospective at the Musée du Jeu de Paume with 139 works, including three paintings from the *Slav Epic*. By then Europe was in the grip of totalitarian and authoritarian dictators. Adolf Hitler's National Socialist Germany was a particular threat to Czechoslovakia, which remained an island of democracy. In view of the increasing political repressions and the climate of fear in Europe Mucha planned a triptych, *The Age of Reason*, *The Age of Wisdom*, and *The Age of Love*, but was no longer able to realise the project.

With the Munich Agreement in 1938 Hitler annexed the so-called Sudetenland, Czechoslovakia's border regions inhabited mostly by Germans. On 15 March 1939, the German Wehrmacht marched into Prague. The political system that Mucha had served with such idealism for 20 years of his life ceased to exist. The National Socialists referred to the occupied country as the "Protectorate of Bohemia and Moravia." As a prominent representative of Czech nationalism, Mucha was arrested by the Gestapo and interrogated for several days. As a consequence of his treatment his health rapidly deteriorated after his release. On 14 July 1939, seven weeks before the beginning of the Second World War, he died of pneumonia. Although public gatherings were forbidden by the German occupiers, a large number of mourners attended his burial. He was laid to rest in the Slavín section of Prague's Vyšehrad Cemetery, which is reserved for the most famous Czech personages.

WILFRIED ROGASCH *studied history and art history in Göttingen, Munich and Oxford. Since 1989 he has lived in Berlin as a freelance exhibition curator and writer. Among his numerous publications are* Castles and Gardens in Bohemia and Moravia, Germany's Treasure Houses, Art in Noble Collections, Bavaria in 24 Chapters, *and* The 100 Most Beautiful Churches in Upper Bavaria.

1 "The World's Greatest Decorative artist," *New York Sunday News*, Easter Sunday, 3 April 1903.
 Included in the issue was Mucha's poster *Friendship*, an allegorical depiction of the friendship
 between France and the United States, see p. 77 r in this present publication.
2 Jiří Mucha, *Alfons Mucha. Ein Künstlerleben*, translated from the Czech by Gustav Just (original
 edition: *Kankán se svatozáří. Životopis Alfonse Muchy*, Prague 1969), Berlin (East), 1986, p. 174.
3 Ibid., p. 171.
4 Alfons Mucha, March 1904, quoted from Tomoko Sato, *Mucha*, Cologne 2018, p. 7.
5 Jiří Mucha 1986 (as in note 2), p. 458.
6 Letter from William Henry Goodyear to Alfons Mucha, 1919, in: Jiří Mucha 1986 (see note 2),
 p. 504.

29 *Self-Portrait* in Mucha's Paris atelier in the Rue du Val-de-Grâce, with posters for Sarah Bernhardt in the background, ca. 1901

BIOGRAPHY

Alfons Mucha
1860 – 1939

1860–1877 Alfons Maria Mucha is born on 24 July 1860 in Ivančice, a small town in southern Moravia, as the son of the court usher Ondřej Mucha and his wife Amálie. From 1872 he attends the Slavic Gymnasium (grammar school) in the Moravian capital Brno. Since he has a fine singing voice he is awarded a stipend as a choirboy in the Brno cathedral choir, enough for him to live on. His parents cannot support him, because his father's wages as a court usher are low, and his father, unusually at the time, has invested money in the education of Mucha's elder sisters.

After repeating both the second and third classes at the gymnasium, he is expelled from the school without a certificate. He takes a job as a court clerk in Ivančice that his father has arranged for him but that he dislikes.

1878–1881 Mucha journeys to Prague hoping to study at the Academy of Arts, but his application is rejected. So he designs invitations, programmes, posters and apparently even stage sets for the amateur theatre in his home town and receives instruction in drawing from the Moravian artist Josef Zelený. In 1879 he is taken on as an apprentice at Brioschi, Burghardt, and Kautsky, a Viennese firm specialising in theatre scenery. Following a catastrophic fire at Vienna's Ringtheater, in 1881 the firm loses its most important client, and is forced to release its employees, including Mucha.

1882/83 Since it is too expensive to live in Vienna without steady employment, Mucha moves to Mikulov in southern Moravia, a small town close to the Austrian border. He tries to make a living by painting portraits of local dignitaries. In 1883 he becomes acquainted with Count Eduard Khuen-Belasi, who engages him to decorate the dining room in his newly built Castle Emmahof, named after the count's wife. Subsequently, he is sent to the count's younger brother, Egon Khuen-Belasi, at Castle Gandegg, near Bolzano in Tyrol.

1884 With Count Egon, an amateur painter himself, Mucha undertakes a study trip to Venice, Florence, Bologna and Milan. They do not go to Rome. Mucha considers himself to be too immature to appreciate the city, and will only visit the Eternal City in his old age.

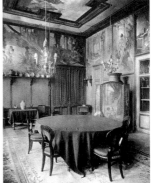

30 Dining room in
Emmahof Castle, with
wall paintings and
a folding screen by
Alfons Mucha, 1882

31 *Self-Portrait* in Mucha's room in the
Rue de la Grande Chaumière, Paris, 1892

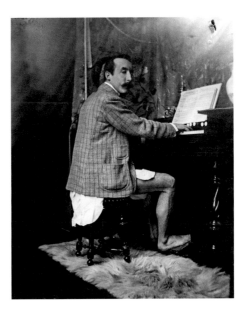

32 Paul Gauguin playing
Mucha's harmonium in the
Rue de la Grande Chaumière,
Paris, ca. 1893/94

1885 In the autumn he passes the entrance exam at the Academy of Fine Arts in Munich, considered the best art academy in the German-speaking region. He is supported financially by Count Eduard Khuen-Belasi.

1886–1889 The Czech congregation in Pisek, North Dakota, U.S.A., commissions Mucha to paint an altarpiece picturing the Slavic missionaries Cyril and Methodius. In 1887 he moves from Munich to Paris and attends the respected Académie Julian, then in the following year switches to the equally well-known Académie Colarossi. In January 1889 he receives the news that his patron will no longer be supporting him.

1891/92 Mucha becomes acquainted with Paul Gauguin, who will later occasionally use his atelier. In 1892 he receives the commission to illustrate the book *Scènes et épisodes de l'histoire d'Allemagne* by the noted historian Charles Seignobos. Mucha produces 33 illustrations for the work. In the same year he begins teaching drawing.

1894/95 Mucha is commissioned to produce a poster for the première of Victorien Sardou's play *Gismonda* at the Théâtre de la Renaissance, in which the world-famous actress Sarah Bernhardt, the owner of the theatre at the time, plays the title role. A six-year exclusive contract follows from this collaboration in 1895: Mucha designs all the posters, costumes and sets for Bernhardt's plays.

1896 He moves from the Rue de la Grande-Chaumière 13 to the genteel Rue du Val-de-Grâce 6, where he sets up an atelier and apartment in elegant rooms. Mucha signs an exclusive contract with the printer F. Champenois. He invents his "Panneaux décoratifs," posters without text and promotional intent, conceived solely as tasteful interior décor: in the first series of four posters, *The Four Seasons*, seductive young women pose in front of background vegetation appropriate to the season.

1897 First exhibitions of Mucha's works in Paris, in February at the Galerie Bodinière with 107 pieces and in March in the Salon des Cent with 118. Mucha uses a letter from Bernhardt as the foreword to the catalogue. Robert de Flers's book *Ilsée, princesse de Tripoli* is published with 134 illustrations by Mucha.

33 At work on the design for a poster for the Imprimerie Cassan Fils, 1896

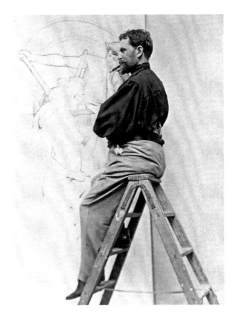

34 Interior of the Bosnia-Herzegovina Pavilion at the 1900 Paris Exhibition showing walls with Mucha's paintings, 1900

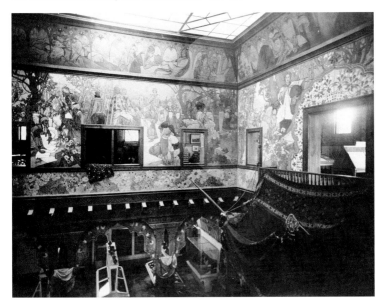

1898 Mucha is initiated into the Grand Orient de France Freemasons lodge, the oldest Masonic organisation in the country. He begins to teach at Paris's Académie Carmen, belonging to the well-known American painter James McNeill Whistler. In the spring he travels to Spain in search of motifs for the illustrations for Charles Seignobos's book *Histoire d'Espagne*.

1899 The Austrian government awards Mucha the commission for the design of the Bosnia-Herzegovina Pavilion at the 1900 Paris World's Fair. In search of motifs, he undertakes a trip to the Balkans, and there has the idea of creating a cycle on Slavic history. The book *Le Pater* (*The Lord's Prayer*) is published with Mucha illustrations.

1900 In recognition of his work for the World's Fair, Mucha is honoured with a silver medal from the exhibition's directors and the Austrian Franz-Joseph medal. In the following year he will be named a knight of the French Legion of Honour.

1901 Mucha becomes a member of the Czech Academy of Science and Arts. With the Paris jeweller Georges Fouquet he creates a *Gesamtkunstwerk* in the "style Mucha." The Czech edition of *Le Pater* (*The Lord's Prayer*) is published.

1902 Mucha travels to Prague with his friend Auguste Rodin to see a major exhibition of Rodin's sculptures. His unsolicited advice to his Czech artist colleagues to consider their own roots rather than imitating the art in Paris, Vienna and Munich causes a scandal. Publication of the extraordinarily successful *Documents décoratifs*.

1903 The Czech art student Marie (called Maruška) Chytilová (1882–1959) is Mucha's pupil briefly, then will become his wife on 10 June 1906 in a marriage ceremony in the Church of St. Roch in Prague's Strachov Monastery.

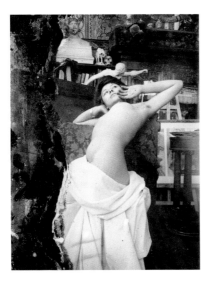

35 Semi-nude model posing in the atelier in the Rue du Val-de-Grâce, Paris, 1902/03

36 Models posing as three warriors for the *Celebration of Svantovit on Rügen Island*, the second picture from Mucha's painting cycle *The Slav Epic*

1904 First trip to the United States, where posters celebrate Mucha as the "World's Greatest Decorative Artist." He becomes acquainted with Charles Richard Crane, a Chicago millionaire with an interest in history, who will finance the picture cycle *The Slav Epic* from 1909. Mucha meets many members of American high society. He even spends the American national holiday, 4 July, with the American president Theodore Roosevelt at his country house in Oyster Bay, Long Island. Although Mucha is celebrated by the American press and passed around from one moneyed circle to the next, he is given fewer commissions than expected.

1905–1908 The *Figures Décoratives* are published in 1905 as a sequel to the *Documents décoratifs* from 1902. Visits the United States a second and third time, teaching and producing a few portraits; however these are much less lucrative than Mucha had hoped. He travels to the United States a fourth time in 1906, this time with his wife. Teaches at the Art Institute of Chicago. In 1908 he designs the interiors of the new German Theater in New York; however the theatre is forced to close for financial reasons after one year.

1909 Mucha's daughter Jaroslava is born in New York. Travels to Bohemia and Moravia. There he produces first charcoal sketches for the *Slav Epic*. Fifth U.S. visit: at Christmastime Crane announces his intention to finance this cycle of 20 large-format paintings.

1910–1913 Mucha begins the decoration of the main hall in Prague's Municipal House (Obecní dům). In 1911 he moves to Zbiroh Castle in West Bohemia, between Pilsen and Prague. In 1912 he travels through Dalmatia with Maruška. Mucha completes the first three paintings of the *Slav Epic*. In 1913 he visits the United States a sixth time and – in search of motifs for the *Epic* – makes study trips to Poland (including Warsaw and Kraków) and Russia (Moscow and St. Petersburg).

1914/15 Outbreak of the First World War: Slavs are forced to fight on both sides. In 1915 Mucha's son Jiří, his later biographer, is born in Prague.

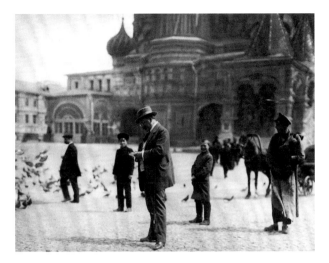

37 Alfons Mucha sketching on Red Square in Moscow, 1913

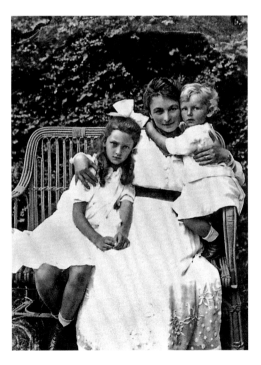

38 Maruška with daughter Jaroslava (left) and son Jiří (right) at Zbiroh Castle, western Bohemia, ca. 1917

1918/19 After the collapse of Austria-Hungary and the founding of Czechoslovakia Mucha designs the young republic's postage stamps and banknotes. The first set of stamps features Prague's Malá Strana with the Hradčany towering over the St. Nikolaus Church. Mucha used portraits of Crane's daughter Josephine and his own daughter Jaroslava as references for two allegorical female figures on the banknotes. Mucha also provided designs for Czechoslovakia's coat of arms and for its military and police uniforms.

1919–1921 Eleven paintings from the *Slav Epic* are shown in Prague's Clementinum, and the show subsequently travels to Chicago and New York. In 1919 Mucha undertakes with his wife and children his seventh and final trip to the United States. In 1920 some 200,000 people visit the exhibition at the Art Institute of Chicago; at the Brooklyn Museum in New York in 1921 it draws some 600,000.

1923/24 Alfons Mucha is elected Sovereign Grand Commander of the Czech Supreme Council of Freemasons. In 1924 he undertakes a study trip through the Balkans looking for motifs for the still-missing paintings of the *Slav Epic*, and proceeds to Mount Athos in Greece.

1928 Mucha and Crane participate in a ceremonial presentation of the completed cycle to the "Czech people" and the City of Prague, along with an exhibition in Prague's exhibition hall. The gift is made with the stipulation that a special building be erected in which the cycle is on permanent display. To this day neither the City of Prague nor the Czech government has honoured that condition.

1930/31 The *Slav Epic* is exhibited in Brno, the Moravian capital and Mucha's home town. He is commissioned to design a stained-glass window, made in 1931, for Prague's St. Vitus Cathedral, in the centre of which are depictions of the Slavic apostles Cyril and Methodius and the Czech saints Ludmilla and Wenceslas.

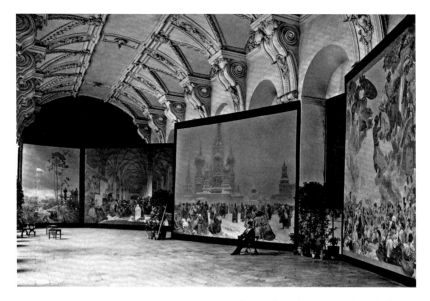

39 Mucha in front of the paintings from *The Slav Epic* exhibited in Prague's Klementinum in 1919

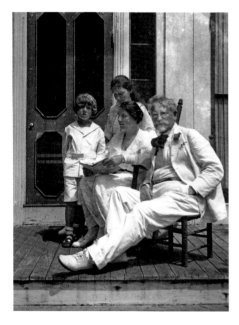

40 The Mucha family on Cape Cod, Massachusetts, U.S.A., 1921

1932–1934 Mucha spends two years with his family in Nice. There, on the French Riviera, he is again active as a painter. Among other works he produces the painting *The Gifts of the Earth* for the dining room of the Kurhotel Thermia in the internationally famous Slovakian spa town Piešťany.

With the proclamation of Adolf Hitler as Reich Chancellor in Germany, in 1933 the National Socialist dictatorship begins. In the following years it will call into question Czechoslovakia's very existence.

1936 Retrospective Mucha exhibitions are held in Paris's Musée du Jeu de Paume and Brno's Museum of Arts and Crafts. Mucha begins work on the triptych *The Age of Reason*, *The Age of Wisdom* and *The Age of Love*, a humanistic appeal to mankind. The work is never completed.

1938 In the Munich Agreement Czechoslovakia is obliged to cede its border regions mainly populated by Germans to National Socialist Germany.

1939 On 15 March Germany occupies the remaining Czech territories as the "Protectorate of Bohemia and Moravia," with Slovakia becoming pro forma independent. Czechoslovakia, which Mucha had championed for decades, ceases to exist. Mucha is interrogated by the Gestapo for several days. After his release his health rapidly deteriorates as a result of the torture. He dies on 14 July and is buried in the Vyšehrad Cemetery in the "Slavìn Division," in which the most important Czech dignitaries are laid to rest.

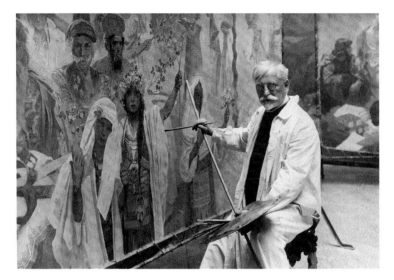

41 Working on the sixth picture from *The Slav Epic: The Coronation of the Serbian King Stephan Dušan as East Roman Emperor*, 1924

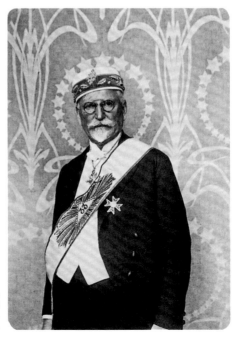

42 Self-portrait in formal Masonic regalia as Supreme Commander of Scottish Rite Freemasonry in Czechoslovakia, Prague, 1930

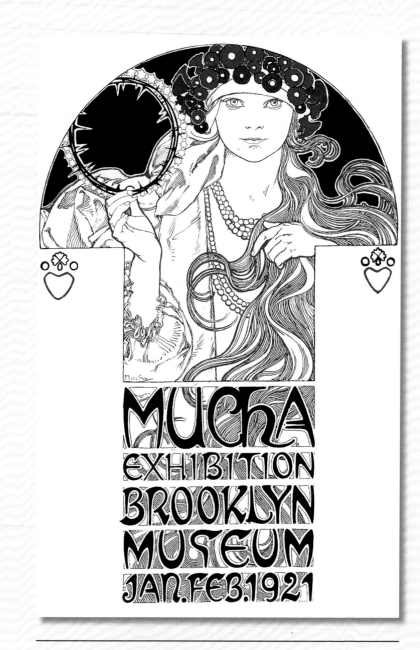

Poster for the Mucha Exhibition at the Brooklyn Museum, New York,
January – February, 1921

ARCHIVE

Discoveries, Documents
1897–1921

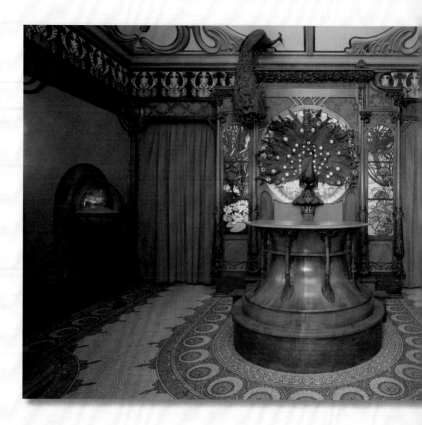

I

Alfons Mucha and one of Paris's most prominent jewellers at the time, Georges
Fouquet, had already successfully collaborated in the design and execution of
pieces of jewellery – some of them for Fouquet's stand at the Paris World's Fair
in 1900, when Fouquet commissioned Mucha in 1901 to redesign in the Art

Ia Reconstruction of the Boutique Fouquet, designed by Alfons Mucha
in 1901, at the Musée Carnavalet, Paris
Ib Design for a wall vitrine in the Boutique Fouquet, ca. 1900, drawing,
crayon on cardboard, 65 × 47 cm, Musée Carnavalet, Paris

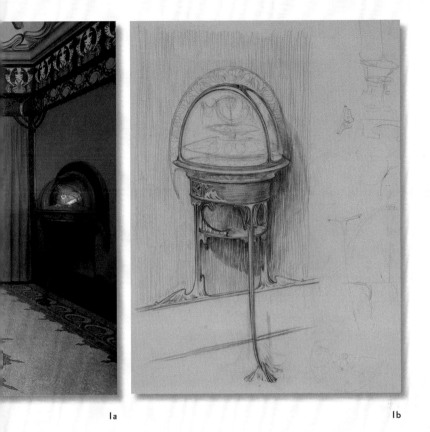

Nouveau style his entire luxurious shop at Rue Royale 6. The relief of a classic "Mucha woman" with long, wavy hair adorned the façade. Inside, the walls, ceiling, floor and furnishings were all created in a uniform overall design. This included the showcases, the sales counters, the lamps, mirrors, gorgeous glass paintings with floral motifs and various sculptures, among them a pair of peacocks, one of them fanning its tail, as symbols of beauty and opulence.

Fouquet bequeathed the entire shop interior to the Musée Carnavalet, Paris's municipal museum housed in a historic palais in the Marais Quarter. There the jeweller's shop is displayed as a reminder of the brilliance of the Belle Époque.

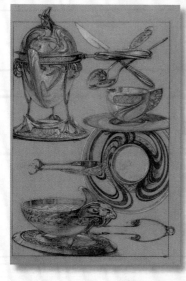
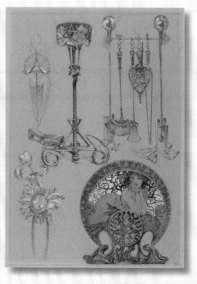

<div align="center">2a</div>

<div align="right">2b</div>

2

In Mucha's Documents décoratifs *from 1902 his imagination and inventiveness knew no bounds in the design of useful everyday objects. Plate 58 pictures extravagant designs for tableware: a samovar, a ram-headed bowl for candy or sugar, a cup and saucer, a décor variant for the saucer, also cutlery and sugar and pastry tongs. All the objects in Plate 68 take on floral forms; there is a multi-piece hearth set complete with bellows, a splendid round fire screen, and a flower or candle stand. In that plate, as in many others from the total of 72, we also see one of Mucha's typical young women. For the publication he produced countless drawings that most impressively attest to his bravura draughtsmanship.*

2a Design for Plate 58 of the *Documents décoratifs*, 1902, pencil and opaque white on cardboard, 54.3 × 40.3 cm, Musée du Louvre, Paris
2b Design for Plate 68 of the *Documents décoratifs*, 1902, pencil, highlighted in white, on cardboard, 57.1 × 44.1 cm, Musée d'Orsay, Paris

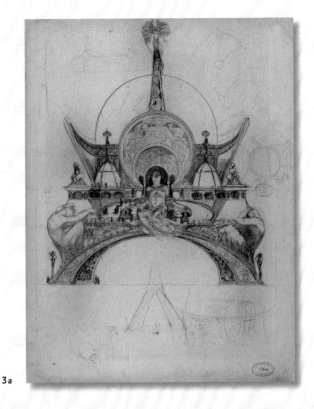

3a

3

Once the Paris World's Fair of 1900 had ended successfully, the idea of an ex-position on the theme "World Religions and Humanity" was floated. A special society was founded to organise such a project, but it was never realised. Mucha presented sketches for the fair's central structure, the "Pavillon de l'homme." His design called for the demolition of the entire Eiffel Tower above its bottom platform, which was to serve as the base of the new building. This idea alone was highly unlikely to be realised. There had been calls for the demolition of what was then the tallest structure in the world after the 1889 World's Fair, but nothing came of them, and after their initial disdain for the

3a First design for the "Pavillon de l'homme," 1897, pencil on cardboard, 65 × 50 cm, Musée d'Orsay, Paris

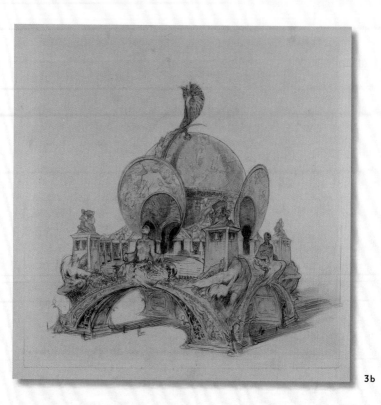

3b

Eiffel Tower, Parisians had grown accustomed to it. It had meanwhile even become a symbol of the city.

Mucha's designs envisaged gigantic allegorical sculptures larger than any such works previously known. They were to represent mankind's evolution from its beginnings up into a spiritual future – themes that Mucha had already dealt with in his illustrations for Le Pater (The Lord's Prayer), from 1899. A huge globe was to crown the bizarre structure, and rising above it there would be the World Spirit as mankind's protector. Climbing up toward him is a group of people who have trodden the path of virtue and righteousness.

3b Second design for the "Pavillon de l'homme," 1897, pencil and water-colour on cardboard, 50.1 × 64.9 cm, National Gallery, Prague

4

The Easter edition of the New York Sunday News *in 1904 included the Mucha colour lithograph* Friendship, *by "the World's Greatest Decorative Artist." This allegory of the friendship between France and the United States pictured two women, the older one tenderly placing her arm across the shoulder of the younger one, their hands touching. The older woman's pale blue gown is strewn with fleurs de lys, while that of the younger woman is adorned with white stars with red-and-white ribbons wafting about her shoulders – the famous "stars and stripes" of the American flag. A wreath of leaves in the younger woman's hand symbolises unity and concord.*

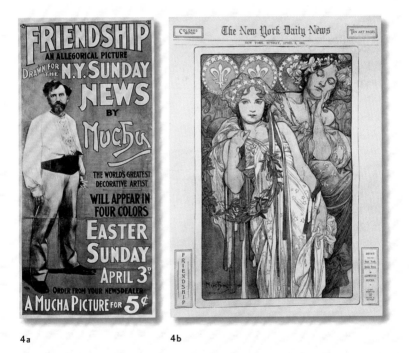

4a

4b

4a New York poster advertisement for Mucha's lithograph *Friendship*, 1904
4b The *New York Daily News*: the art insert dedicated to Mucha in the Sunday edition for 3 April 1904

SOURCES

—

PHOTO CREDITS

The originals were graciously provided by the collections and museums named in the captions or by the archives listed below (the numbers indicate the page numbers):

—

TEXT EXCERPTS HAVE BEEN TAKEN FROM THE FOLLOWING PUBLICATIONS:

(see also the notes on p. 55)

Jiří Mucha, *Alfons Mucha. Ein Künstlerleben*, Berlin (GDR) 1986.
Alfons Mucha, ed. by Agnes Husslein-Arco et al., Munich 2009
Tomoko Sato, *Mucha*, Cologne 2018